AROUND THE WORLD
CRAFTS

GREAT ACTIVITIES FOR KIDS WHO LIKE HISTORY, MATH, ART, SCIENCE AND MORE!

KATHY CECERI

"HANDS-ON LEARNING" COLUMNIST FOR HOME EDUCATION MAGAZINE

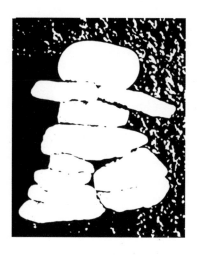

Crafts for Learning
7 Pearl Street
Schuylerville, NY 12871
www.craftsforlearning.com
kathy@craftsforlearning.com
2008

Around the World Crafts

Great Activities for Kids who like
History, Science, Art, Math and More!

By Kathy Ceceri

Published by:
Crafts for Learning
7 Pearl Street
Schuylerville, NY 12871
www.craftsforlearning.com

These projects first appeared in Home Education Magazine in a different format.

First Edition
Printed in the United States of America

ACKNOWLEDGEMENTS

Thanks to the students in the following programs for helping me develop my class World History Through Crafts and allowing me to use photos of their work:

- WSWHE BOCES (Washington-Saratoga-Warren-Hamilton-Essex Board of Cooperative Educational Services) Project Enrich, and its directors Lynne Rosenthal and June Leary;
- Saratoga Springs Public Library afterschool program;
- SAGE (Shenendehowa Advocates for Gifted Education) Saturday Scholars;
- all my friends in Saratoga Area Homeschoolers;

and especially to Helen Hegener, editor and publisher of Home Education Magazine, for her enthusiastic reception to my Hands-on Learning column and for encouraging me to create this book.

TABLE OF

CONTENTS

DECORATIVE ARTS

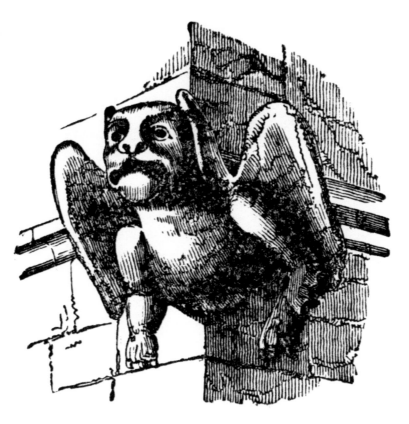

Basketmaking
A Useful Craft Becomes an Art form

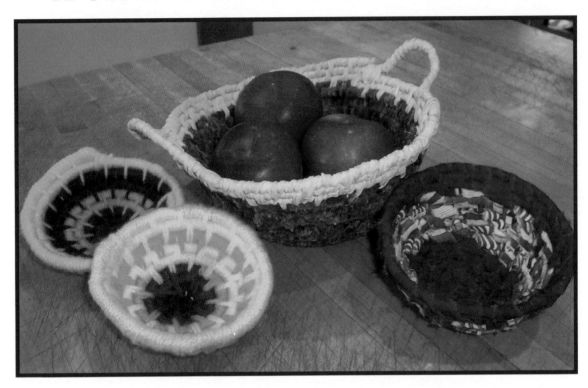

The humble basket is probably among the earliest human inventions. Inspired by a tangled mass of vines or a bird's nest, the first baskets -- used for toting supplies, sifting grain, and even carrying water -- were probably more functional than decorative. (That, and the fact that reeds, vines and bark don't last as long as stone and metal, are why you won't see a lot of ancient baskets in museums.) But over the centuries, different cultures began developing their own unique styles. It took a while, but eventually museums started preserving baskets made by people who remembered the ancient techniques. Today baskets are used to hold things as well as to make our homes look beautiful.

There are many ways to make a basket, but coiling is a method found around the world. In the Southwestern United States, the Navajo create coiled wedding baskets of willow or sumac, with triangles representing mountains and a path leading to the rim, while eastern Native Americans baskets are made with bundled pine needles bound with thread. In South Carolina, sweetgrass coil baskets are still made using skills brought by slaves from Sierre Leone and Senegal. In Morocco and Iran, multi-colored coiled pots are stitched with wool. And in Africa, coiled baskets come in a variety of shapes: flat Ugandan trays, bulbous Zulu beer baskets, and delicate Tutsi hut baskets with high pointed lids. In Zimbabwe the women use both grasses and recycled plastic. For many African communities, traditional basketry has been revived as a major source of income.

Coil Basket Directions

You can make a simple coiled basket from all kinds of left-over materials. All you need is a thick core like clothesline, manila rope or bunched-up fabric, which spirals up from the bottom of the basket and provides the main support; a thinner wrapping to wind around the core and stitch it together, such as yarn, raffia (use 2-3 strands, trimmed evenly), rags (tear long strips of fabric 1/2 inch wide) or twine; and a large tapestry needle.

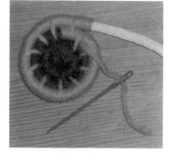

1. Start with at least 10 feet of core and about 3 feet of wrapping. Thread one end of the wrapping through the needle for taking stitches. You will wrap with the other end.

2. Lay an inch of wrapping along the end of the core. Begin winding the wrapping tightly around the core and the end of the wrapping. Cover about 3 inches.

3. Roll the wrapped portion of the core into a spiral to start the bottom of the basket. Take the needle end of the wrapping and poke it through the center of the spiral and pull tight. Take a few more stitches around the coil to hold it securely.

4. Now wind the wrapping 5 turns (1-2 for fabric strips) around the core. Then take another stitch into the coil below to fasten. Continue wrapping and stitching until you've got a flat circle big enough for the base of your basket.

5. To shape the sides, start coiling the core on top of the previous coil. Flare out the sides as desired.

6. To add more wrapping, lay the first inch of the next piece of wrapping along the core next to the last inch of the old piece. Continue wrapping from where you left off, covering both ends of wrapping so that they don't show. Thread the needle onto the new wrapping and continue taking stitches as needed.

7. To add more core, cut the ends of the old piece and the new piece at matching angles, and fit them together as smoothly as possible. Wind the wrapping around the splice tightly to hold it in place.

8. For handles on the top coil, wrap a loop of core separately for several inches, then reconnect it to the rest of the basket.

9. Finish the basket by tapering the end of the core, winding it tightly with wrapping, and taking a few stitches to hold it securely. Weave the end of the wrapping back into the basket so it doesn't show.

Once you've got the hang of it, go natural using pine needles or grasses you've harvested yourself. Check the basketmaking resources (page 12) to learn how to prepare them and different stitches that will make your basket really special. With so many different types of coiled baskets to choose from, you can create a basket collection of your very own.

Weave a Heart Basket

These heart baskets are a Scandinavian tradition. In Sweden, they are traditionally woven from birch bark, using the white outside and pink inside for contrast. In Denmark, it is said that children's author Hans Christian Andersen invented them as Christmas tree decorations. You can attach a handle from the center of one side to the other and fill them with treats.

Swedish birch bark basket

1. Fold a sheet of pink and a sheet of white letter-sized paper (or any two colors) together. Draw the rounded shape shown in the first photo with the straight edge on the fold. Cut through both pieces of paper, making three weaving strips.

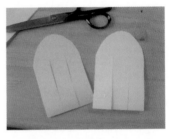

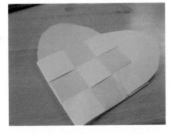

2. Separate the two pieces of paper and position them as shown in the second photo. Begin to weave by slipping the top pink strip **inside the fold** of the top white strip.

3. Continue by slipping the top white strip **inside the fold** of the middle pink strip. Then slip the bottom pink strip **inside the fold** of the top white strip.

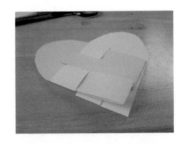

4. Repeat with other two strips, alternating colors.

5. If you've done it right, you should be able to open the basket.

Sources and Resources

Books

Art of the Basket: Traditional Basketry from Around the World by Bryan Sentence

Natural Baskets: Create over 20 Unique Baskets with Materials Gathered in Gardens, Fields and Woods edited by Maryanne Gillooly

Circle unbroken: the story of a basket and its people by Margot Theis Raven

Baskets by Meryl Doney

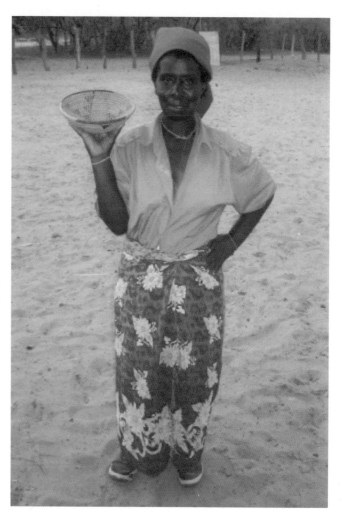

A member of a basket-weaving club in Zimbabwe (Photo: Heidi Ricks)

Websites

Native American Basketry
www.nativetech.org/basketry
Directions for different coil styles

Basketmakers
basketmakers.org
Articles on making all kinds of baskets

V.I. Cane and Reed
basketweaving.com
Supplies

Peg's Basketry
pinebaskets.tripod.com
Pine needle coil basket books and supplies

Gargoyles
Medieval Beasts in Architecture

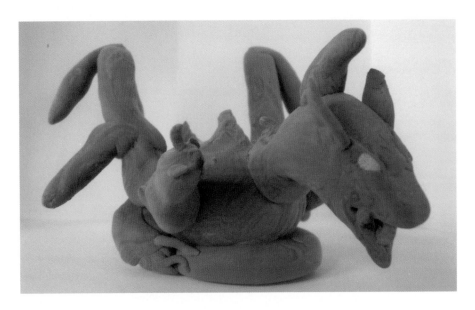

The art of the Middle Ages is filled with animals. Majestic lions, noble horses, shy unicorns and evil serpents were not only used as decoration, they also served to teach moral lessons that could be understood even by people who couldn't read.

For instance, the hoopoe, a bird said to live around tombs, was believed to care for its parents in old age, as the Bible commands humankind to do. Scenes from Aesop's fables and the tales of the trickster Reynard the Fox were also popular. Books called bestiaries, filled with colorfully-illustrated descriptions of exotic creatures, were bestsellers, and animal likenesses were carved into wooden church pews and woven into the tapestries used to line damp castle walls.

But the beasts in these works of art were hardly realistic, because most Medieval artists had never seen the creatures they were depicting. Instead, they based their designs on ancient texts and drawings, traveler's wild tales, and pagan folklore. Crocodiles with dog's snouts and blue, green and red panthers were common, and when it came to things such as gryphons and manticores, artists let their imaginations run wild.

Among the most bizarre creatures from the Middle Ages are the sculptures known as gargoyles. Crouched atop cathedral roofs, they originally took their name from their function as rainspouts. In fact, the word "gargoyle" is related to "gargle." Often gargoyles are monsters combining features of human, animal and demon. Others are cartoon-like exaggerations of individuals or types of people the stonecarver knew. In the Middle Ages stonecarving was a highly respected, and highly paid, craft, and the gargoyles they created from marble or limestone are still known today for their lively, if ghoulish, personalities.

Clay Gargoyle Directions

Real gargoyles were usually sculpted from stone, and working with clay is a little different. With clay the artist builds the sculpture up piece by piece, while stonecarvers start with a block of stone and chip away at it. If you want to try the stonecarver's technique, make a big rough block of clay, then carve it away with pottery tools. To make clay look like marble or limestone, take a hunk of white and mix it with a small bit of black and/or red to create light grey or pink. Don't mix it completely – the different shadings will look more realistic. To create veins of color, add small bits of black or red and press and stretch the clay.

Keep in mind that your sculpture is meant to be viewed from at least three sides – and from below, if you will be displaying it on a high shelf so it looks down like a "real" gargoyle. Keep turning it around to see how it looks from different angles. Be sure that the bottom is heavier than the top, so it can stand on its own; it will also make the material look more solid. Make the lines and indentations nice and deep, because they help create shadows which make the shape stand out. You might want to put your gargoyle on a small pedestal for a more authentic look.

Make the pedestal resemble the side of a castle or cathedral by carving lines into it to that outline the "blocks" of stone.

Model Magic clay from Crayola is easy to work with. It is good for making gargoyles to sit on a desk or shelf, but let it harden first because it can stain furniture when soft. If you use a heavier type of clay and let it harden, you can also make gargoyles to use as bookends, candleholders or paperweights.

Why gargoyles?

We don't know why gargoyles and other gruesome images -- mashing together different animals and even humans -- were used as decoration on medieval cathedrals and monasteries. And apparently, even back then folks were puzzled. In 1127, St. Bernard of Clairvoux complained:

What are these fantastic monsters doing in the cloisters under the very eyes of the brothers as they read? What is the meaning of these unclean monkeys, strange savage lions and monsters? To what purpose are here placed these creatures, half beast, half man? I see several bodies with one head and several heads with one body. Here is a quadruped with a serpent's head, there a fish with a quadruped's head, then again an animal half horse, half goat... Surely if we do not blush for such absurdities we should at least regret what we have spent on them.

(In other words, they're not only disgusting and distracting, they're also a waste of money!)

Invent Your Own Medieval Beast

Combine two or more beasts to make a new one!

- What is your beast's name?

- What other beasts is it made up of?

- What is it like?

- What are its special characteristics?

- What is it a symbol of?

The Cloisters, the Medieval wing of the Metropolitan Museum, in New York City

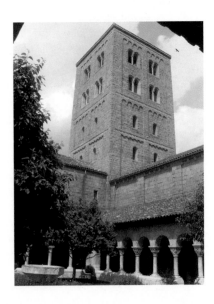 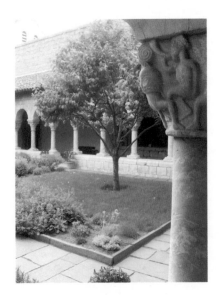

Sources and Resources

Books

Questionable Creatures: A Bestiary by Pauline Baynes

The Hunchback of Notre Dame by Victor Hugo

The Gargoyle on the Roof by Jack Prelutsky

Night of the Gargoyles by Eve Bunting, illustrated by David Wiesner

Cathedral Macaulay, David

Cutters, carvers & the cathedral Ancona, George

Gargoyles, monsters, and other beasts Rieger, Shay

Cathedral mouse Chorao, Kay

Movies

The Hunchback of Notre Dame (based on the book by Victor Hugo) in three versions: the 1923 silent version with Lon Chaney, the 1939 classic with Charles Laughton, and the Disney animation.

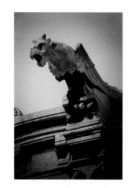

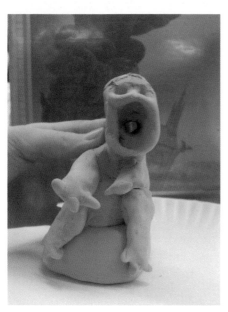

Websites

The Medieval Bestiary
http://bestiary.ca

Walter S. Arnold
www.stonecarver.com

New York Carver www.newyorkcarver.com

Monster Walks www.aardvarkelectric.com/gargoyle/walks.html

Washington National Cathedral
www.cathedral.org/cathedral/visit/self.shtml

Colonial Paper Crafts
An Early American Pastime

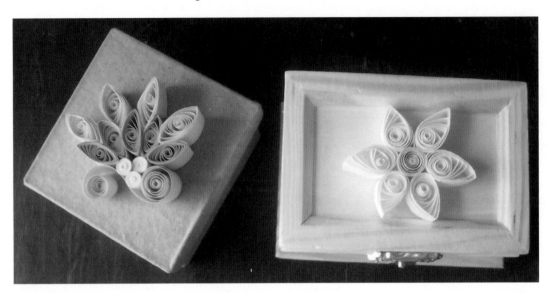

Back in Colonial America, hobbies were serious business. Whether they were taught at home or at school, girls were expected to learn their own kind of three "R's": refinements, recreations, and reading novels. As author Felice Hodges writes in her interesting book *Period Pastimes: A Practical Guide to Four Centuries of Decorative Crafts*, the well-bred daughters of New England's wealthiest families didn't cook and clean; they had servants to do that. And they certainly didn't go out and get jobs – attracting a husband was supposed to be their main occupation. Instead, these ladies of leisure filled their days dabbling in "the pretty arts," such as needlework, music, dancing and watercolor painting. One of the most popular hobbies of the time was "quilling," the art of making designs using curled-up strips of paper.

Quilling's strange name comes from the quills used to roll the paper strips back when the art form came over with the English colonists. In Europe, where some accounts trace it back to Medieval nuns who recycled the gold-tipped edges of pages from holy books, it is known as "paper filigree." But whatever it is called, the work it produces can be very elaborate and versatile. Magazines and pattern-books of the time were filled with instructions for quillwork designs that could be used to decorate trays, tea caddies, fireside screens and tables. Furniture makers created jewelry boxes, mirror frames, and entire cabinets with special panels meant to be filled with mosaics made of the paper scrolls.

Lucy Steele, one of the characters in Jane Austen's 1811 novel *Sense and Sensibility*, even uses quillwork to show her good breeding when bullied into making a present for her hostess's little girl:

Lucy directly drew her work table near her and reseated herself with an alacrity and cheerfulness which seemed to infer that she could taste no greater delight than in making a filigree basket for a spoilt child.

Today, quillwork is used to make greeting cards, earrings, mobiles and holiday ornaments. You can buy inexpensive quilling tools and quilling paper in all widths, colors and textures, as well as more specialized devices for sizing curls and fringing paper. But special tools aren't really needed – all it takes is everyday craft materials and some imagination. And the technique can be mastered in minutes.

Quilling Directions

Ordinary copier paper is fine for beginning quillers, and comes in pastel and neon colors as well as white. Cut the paper into strips the long way, a few sheets at a time, using scissors, a paper cutter or a shredder. The younger the quiller, the wider the strip: half-inch-wide for little fingers, quarter- or one-eighth-inch for more experienced crafters. You only need two or three sheets to get started.

Materials

Paper strips
Waxed paper
Glue
Cocktail straw (cut a ¼ inch slot in one end)
Flat toothpicks

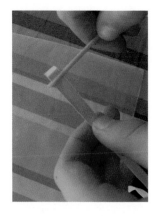

1. Lay out your paper strips. Tear off a placemat-sized square of wax paper to work on (it protects surfaces and keeps the glued quillwork from sticking to the table). Squirt a small amount of white glue onto a corner of the wax paper. Put a flat toothpick for spreading the glue on your waxed paper.

2. Choose a strip of paper. Slip the end of the paper into the slit on the straw's tip to hold it in place. Now turn the straw, wrapping the paper strip around it evenly and tightly, until the strip of paper looks like a dollhouse-sized roll of toilet paper.

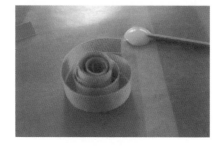

3. Carefully slide the roll off the tool and let it spring open to get the size coil you wish. For a closed coil, dab the tip of the flat toothpick into the glue and use it to spread a tiny amount on the loose end. Press the glued end where you want it to stick and hold it in place with your fingers for a few seconds until the glue begins to dry.

4. When it is dry, pinch the closed coil to make teardrops, pointy leaves, semi-circles, diamonds. You can also leave the coil hanging open to create scrolls, or roll each end separately for different effects.

5. Make more shapes, and attach them with more glue into any design you like.

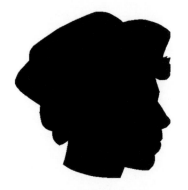

Silhouettes

Before photography was invented, silhouettes were the cheapest, quickest and most accurate way to make a likeness. Compared to having a portrait done by a painter or sculptor, having an artist make black paper cut-out or ink profile was a bargain. In fact, it was named after the French Finance Minister Etienne de Silhouette, a well-known penny-pincher! It was also popular with early Quakers, who objected to having their portraits drawn or painted for religious reasons, but accepted likenesses drawn from tracing a shadow and trimming out the resulting shape.

Over time silhouettes went from plain black and white to bronzed or color, and from paper to fine ivory, plaster, or glass. King George III and Queen Victoria had their silhouettes done; it wasn't until the 20th century that they were replaced completely by photographs.

You can cut a silhouette "by eye," using your scissors to "draw" the profile of your subject. But if you prefer to trace the shadow of your subject, here are the directions:

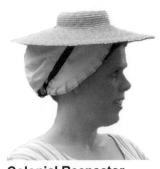

**Colonial Reenactor
Sharon Peck**

Materials

Black and white construction paper or card stock
(Optional: White copier paper)
Glue stick
Scissors
Strong lamp
Masking tape
Pencil

1. Place your subject's chair between the lamp and the wall so that they are facing sideways.

2. Tape the drawing paper onto the wall so that the shadow of the subject's head fits in it.

3. Trace your subject's shadow onto the black paper. If the shadow is hard to see, you can glue a piece of white copier paper onto the piece of black construction paper and tape the two sheets to the wall with the white paper facing out. Trace the shadow onto the white paper.

4. Ask your subject to sit very still while you carefully trace around the shadow with the pencil.

5. Cut out the silhouette, following the pencil line. Glue the silhouette (black side up) onto a piece of white construction paper or card stock.

Sources and Resources

Books

Period Pastimes: A Practical Guide to Four Centuries of Decorative Crafts by Felice Hodges

The Book of Paper Quilling: Techniques and Projects for Paper Filigree by Malinda Johnston

Quilling: Paper Art for Everyone by Betty Christy

Twirled Paper by Jacqueline Lee (a Klutz book and kit with supplies)

Websites

Lake City Crafts
www.quilling.com

Michael Pierce, silhouette miniaturist
www.arunet.co.uk/tkboyd/tk1mp2.htm

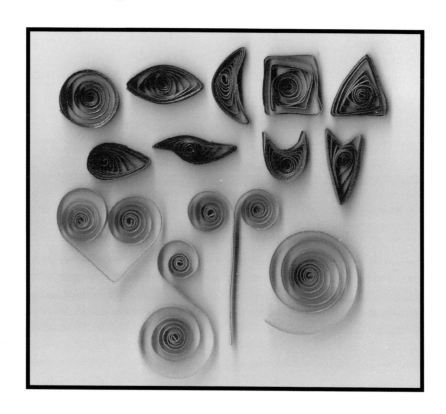

Iron Age Celtic Metalwork
Solving a Mystery with Archeology

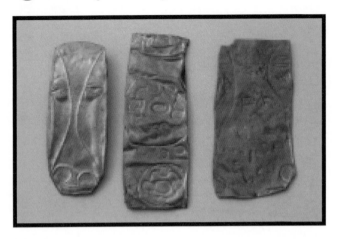

In 1983 in England, workers cutting peat moss in Lindow Moss bog discovered a body and called the police. The victim had been strangled, hit on the head, and stabbed, and the authorities knew just where to go: a local man whose wife had disappeared 25 years earlier. When police told him of their find, the man confessed to his wife's murder. So it was a surprise to all involved when experts declared that the body belonged not to the unlucky wife, but to a man who had died nearly 2,000 years ago! What was the truth behind the mysterious bog body? The answer came through archeology.

Archeology is the scientific study of past human cultures through material remains. Archeologists dig up **artifacts** – things made and left behind by the people they're studying – and scientifically analyze them to figure out when the artifacts were made, how they were used, and how they ended up in the place they were found, years and years later. Occasionally, as in the case of the Lindow Man, they also find remains of the people themselves. Radiocarbon dating told researchers that Lindow Man lived between AD 20 and 90 – the time when a tribe of people known as the Celts occupied Britain.

From around 800 BC until AD 43, when Roman armies invaded Britain, the Celts were the most powerful tribe throughout northern Europe. This was the Iron Age, and metalwork was a specialty of people of the region. Elaborate brooches (pins), torcs (neck rings), and arm bands, as well as ceremonial shields, helmets, cauldrons and swords, are among the artifacts discovered where Iron Age Celts lived. They decorated them with designs featuring animal and human heads or with patterns such as the triskeles, a wheel made of three running human legs (three being a special number to the Celts). But Celtic buildings were made of straw and mud that did not survive the centuries. Instead, most artifacts have been found, like the Lindow Man, in water.

Although the Celts did not have a written language of their own, archeologists know from the descriptions written by the invading Romans that the Celtic priests, the Druids, worshipped gods and goddesses who were part of the natural world in their secret ceremonies. For instance, every winter solstice Druids would give out sprigs of mistletoe to hang over doorways as protection from evil. Heather was another sacred plant with connections to the spirit realm. Water was connected to the Otherworld, where the Druids would place ceremonial offerings of valuable handicrafts – and, it was said, human sacrifices – in rivers, lakes and bogs.

As it happens, the sphagnum moss that grows in swampy peat bogs turns the water to acid that kills bacteria. So instead of decomposing, Lindow Man's soft body parts were preserved by the bogwater the same way tannic acid turns animal hides into leather. His bones, clothes and shoes had dissolved, but archeologists found traces of his last meal in Lindow Man's stomach. It consisted of bread cooked over a fire of heather branches, and a drink made of mistletoe pollen. Archeologists put together the clues – his "triple" murder, his watery grave, and the sacred plants he ate just before his death – and concluded that Lindow Man was the victim of human sacrifice.

Celtic Jewelry Directions

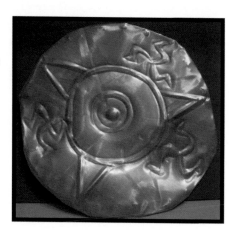

You can make a replica of an Iron Age arm band or ceremonial shield covered with Celtic designs out of copper foil from the art store or even an aluminum baking pan. You can turn your shield into a pin to wear on your cloak.

Materials:

Scrap paper
Copper foil (30 mils thick) or aluminum baking pan
Embossing tool with a rounded point (a lift-erase pad drawing stick works well)
Sheet of craft foam or other soft surface to work on
Tacky glue
Sequins or decorative "jewels"
Stick-on pin fastening

1. Look at the resources at the end of this section to find a Celtic design that you like.

2. Draw your shield or bracelet first on a piece of paper. Then draw a margin about ½ inch around the edge. This will be your pattern for cutting your copper or aluminum.

3. Use scissors to cut the foil the same size as your pattern. Handle the metal carefully, as the edges may be sharp.

4. Put your soft surface under your piece of foil with the BACK facing up. Fold the edges towards you and press down smoothly with your embossing tool or a spoon.

5. On the back of the foil, use the embossing tool to draw your design. It will "pop out" on the front. Try using different pressures and angles with the tool to get different effects. To make the design stand out even more, turn the piece over and outline the design on the front.

6. Bend the bracelet to fit around your wrist, or attach a pin fastening to the back of your shield, near enough to the top so that the pin won't tip forward when you're wearing it.

The Druids

The Druids were the priests in Celtic society, ruling over both religious and political life. Their secret rituals have remained shrouded in mystery to this very day, but hints about their sacred objects have come down to us from the reports of Roman conquerors – and in the echoes of their practices still found in modern life. For instance, special days in the Celtic calendar are reflected in many of the holidays still celebrated today. They include:

- *Samhain*, the Celtic New Year, on October 31. On this day the line between the world of the living and the world of the dead was believed to blur, allowing departed souls to come visit. Today we dress up in scary costumes and walk the streets on this night, which is now known as Halloween.

- *Yule*, the Winter Solstice, the longest night of the year. In a special ceremony five days after the new moon following this night, Druids would cut mistletoe vines off oak trees, using a special white cloth to catch them so they did not touch the ground. The sprigs were given out to the people as protection against evil spirits.

- *Oester*, the festival of the Spring Goddess, which occurs on the first full moon after the spring equinox, in March or April. Its symbols are the hare (a relative of the rabbit), because of its breeding habits, and the egg, which represents new life. Those symbols today are associated with the Easter Bunny.

Bog Mummy Facts

- Iron Age Bog Mummies have been found throughout Britain and Northern Europe.

- Another sacrifice, Tollund Man, was hanged with a leather cord and cast into a Danish bog 2,300 years ago.

- Oldcroghan Man's fingertips are clear enough for police to take his prints. He may have been a rival of the king.

- Peat bogs were drained and the peat moss cut into chunks to be burned as fuel to heat homes.

- Today dried, dead peat moss is more commonly mixed with garden soil to make it lighter. Living sphagnum moss is used for potting hanging plants. It will turn green and send out little tendrils in a moist terrarium.

Sources and Resources

Books

Bog mummies: preserved in peat by Charlotte Wilcox

Bodies from the Bog by James M. Deem

Step into The Celtic World by Fiona Macdonald

The Ancient Celts by Patricia Calvert.

Everyday Life of the Celts by Neil Grant

A Street Through Time by Anne Millard

Motel of the Mysteries by David Macaulay

Butser Ancient Farm
www.butser.org.uk
Re-enactment of an English Iron Age farm

Mr. Donn's Iron Age Celts
http://celts.mrdonn.org/dailylife.html
A teacher's site full of history info and links

Websites

BBC – Iron Age Celts
www.bbc.co.uk/wales/celts
An animated Celtic village

Gathering the jewels
www.gtj.org.uk/trails/iron
Welsh culture and Iron Age settlements

The British Museum
www.thebritishmuseum.ac.uk/pe/g50.html
Famous Celtic metalwork

National Geographic
http://tinyurl.com/2h2bg6
Sept. 2007 Bog Bodies feature

TECHNOLOGY

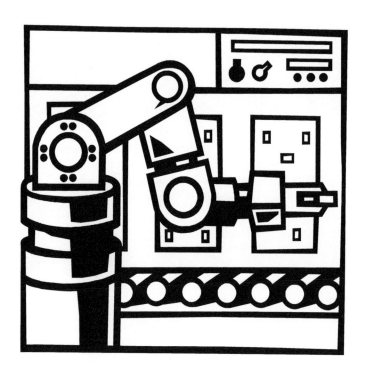

The Abacus
A Math Idea Spreads Across Two Continents

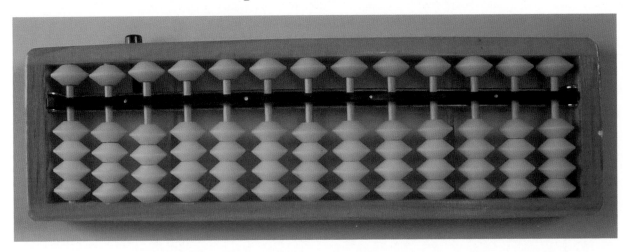

The abacus is sometimes thought of as a low-tech calculator, but it's not. What this little machine of wood and beads does is help keep track of the addition, subtraction and counting going on in your head. Even so, the abacus is so handy it's been around for thousands of years, and it's still used today.

The oldest counting board known is the Salamis Tablet found near Greece, made by the Babylonians in 300 BC. In ancient Rome, *calculi* were small pebbles used for counting. The Romans had a pocket-sized abacus, a board with long grooves to hold pebbles or balls. It was an improvement over adding with Roman numerals, but the loose balls often got lost.

In 1200 A.D the Chinese abacus, or *suanpan,* solved that problem by using a wooden frame with rods that held sliding beads. A horizontal beam separated the frame into lower and upper decks, known more poetically as "heaven" and "earth."

The Japanese adopted the idea from the Chinese around 1600 and called it the *soroban.* In 1930, they streamlined it by using one heaven bead instead of two, and four earth beads instead of five.

While the *soroban* has become very popular, both the *suan-pan* and other designs, including

the Russian *schoty*, which has beads that slide sideways instead of up and down, are still around as well.

Where Did it Come From?

The abacus is a good example of how ideas travel from one culture to another. Just look at its name, which means sand, probably because drawing with a finger on a sandy surface was one of the earliest ways of counting.

Hebrew: *avak* = dust
Phoenician: *abak* = sand
Greek: *abax* or *abakon* = table or tablet (covered with sand or dust)
Latin: *abakos* = abacus
Middle English (around 1300 A.D.)
abacus = abacus

Abacus Directions

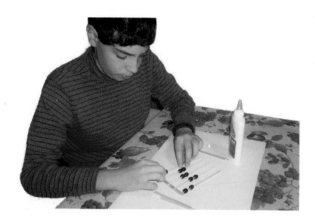

You can make a 2-5 Chinese suan-pan or a 1-4 Japanese Soroban. If you decide to use bigger beads, adjust the length and number of rods accordingly. The "popsicle-stick" design comes from fifth-grade teacher Edward Barinque of Hawaii.

Materials

9 wooden craft sticks (choose ones that are not warped)
5 bamboo skewers, about 1/8" diameter, cut to 4 inch lengths
30/25 plastic pony beads
White glue
Wire cutter (for cutting the rods)

1. Pick out 4 earth beads and 1 heaven bead for each rod. Colors don't matter.

2. Lay the ends of the cut rods onto one craft stick, evenly spaced. Mark their places with pencil. Squeeze lines of glue over the pencil marks. Carefully place the rod ends onto the glue, making sure the rods are square with the craft stick and parallel to each other. Glue another craft stick on top of the rods, over the first stick, in the same way.

3. After the rod ends dry, thread one heaven beads on each rod. Then make the center beam by placing a craft stick underneath the rods, about 3/4" down from the top of the abacus for pony beads, or more if your beads are bigger. Mark and glue the craft stick under the rods and glue another stick on top of the rods as before. Be careful not to let any beads get glued to the sticks.

4. After the glue on the middle craft sticks have dried, thread 4 earth beads on each rod. Place a third craft stick underneath and above the bottom end of the rods and glue as before.

5. If your beads are rubbing against the table when you lay the abacus flat, give them some clearance by doubling or tripling the craft sticks on the back side of the abacus. You can also glue small beads to each corner as feet. Then let dry, flip your abacus over and start counting!

Counting on the Abacus

- Just like writing numbers, each rod or wire represents a place. Going from right to left, you have the ones place, the tens place, the hundreds place, the thousands place and so on.

- Push beads toward the center bar to count them. Clear (zero out) the abacus by pushing all the beads away from the center bar.

- Earth beads are worth 1 each. To show "100," you would push one bottom bead up on the hundreds rod. Heaven beads are worth 5.

- Use your thumb to move earth beads and your index finger to move heaven beads.

- Enter numbers and add LEFT to RIGHT.

- Always take away before you add.

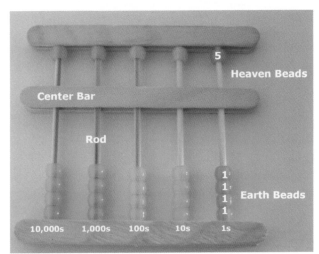

- Practice showing some numbers on the abacus before you go on to addition.

Adding on The Abacus

Show the first number on the abacus. Then add each digit of the second number to the abacus.

Example A: 2+ 1 = ?

Show the first number by pushing up two beads on the ones rod to the center bar. Then add the second number by pushing up one bead on the ones rod. Answer = 3.

If there are not enough earth beads on the rod you are working with, use the heaven bead.

Example B: 2 + 4 = ?

Push up two beads as above. Since there aren't enough earth beads left on the ones rod to push up, you will add 5 - 1 instead: take away an earth bead, then push down the heaven bead on the ones rod. Answer = 6.

If there aren't enough earth and heaven beads on the rod, use one bead from the next rod.

Example C: 2 + 9 = ?

Push up two beads as above. Since there aren't enough beads left to make up 9, instead add 10 – 1: take away an earth bead from the ones rod, then push up one earth bead from the next place over (the tens place). Answer = 11.

Always take away from the current rod before adding to the next rod.

Example D: 113 + 248 = ?

Show 113 (1 earth bead on the hundreds rod, 1 on the tens rod and 3 on the ones rod). Now add 248. Add the 2 on the hundreds rod by pushing up 2 more earth beads. Add the 4 on the tens rod by taking away an earth bead and pushing down the heaven bead (1 + 5 – 1). Finally, add the 8 on the ones rod by taking away 2 earth beads, then going to the tens and adding 1 earth bead (3 + 10 – 2). Answer = 361.

28

Sources and Resources

Books

Easy Abacus by Edward Barinque (www.trafford.com/4dcgi/view-item?item=11460)

Learning Mathematics with the Abacus (Elementary-age workbooks from Malaysia; order in the U.S. through www.nurtureminds.com)

The Abacus: A pocket computer by Jesse Dilson (comes with wooden Chinese abacus)

The History of Counting by Denise Schmandt-Besserat

How to Count Like a Martian by Glory St. John

Count Your Way Through China and *Count Your Way Through Japan* by James Haskins

Websites

Abacus: The Art of Calculating with Beads by Luis Fernandes
www.ee.ryerson.ca:8080/~elf/abacus/index.html
History, pictures, directions and links.

Qi-Journal Virtual Abacus
http://qi-journal.com/culturearticles/abacusindex.html

Tomoe Soroban (a Japanese company that makes soroban)
www.soroban.com/fanzan/indexE.html
A Flash Mental Calculation game that helps you practice reading numbers on the abacus.

The Soroban Education Centre in Singapore
www.soroban.com.sg/
Click on "Museum" to see the fun homemade abacus collection created by the school's co-founder Ms. Phyilly Wong.

The National Library of Virtual Manipulatives from Utah State University
http://nlvm.usu.edu/en/nav/grade_g_2.html
Lots of really cool math applets, including a Chinese abacus (click on "Parent/Teacher" for detailed instructions).

Solar Cookers

and Other Sun-Powered Crafts

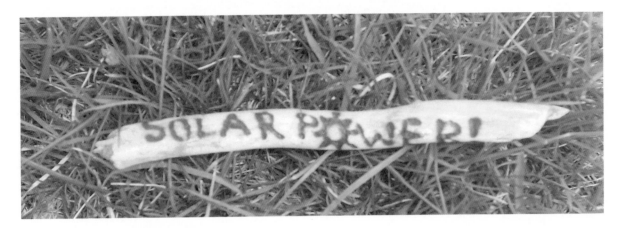

It doesn't have to be hot enough to fry an egg on the sidewalk to cook with the sun. Using everyday materials that absorb and reflect the sun's heat, it's easy to build solar cookers that can melt chocolate or roast marshmallows to crispy goodness in a flash, perfect for making S'mores. And it only takes a simple magnifying glass and a sunny day to create intriguing designs in wood. Of course, too much sun can be dangerous (remember Icarus?), so be sure to use skin and eye protection, and keep an adult around while you try these summertime activities.

The solar cooker works because of three basic principles: light passes through windows easily but heat does not; shiny surfaces can be aimed to reflect light where needed; and dark surfaces absorb sunlight and convert it to heat.

Dark-colored materials look dark to our eyes because only small amounts of visible light rays reflect off of them. The rest are absorbed by the atoms of the object and re-radiated out in the form of infrared, or heat, waves. In an oven, the infrared rays are too long to pass through the window, so they bounce back into the oven.

How hot the oven can get depends on how much heat leaks through the window and walls.

Solar cooking is cheap, easy, and portable. While solar cookers aren't widely used, for obvious reasons (you can't use them at night or when it's cloudy), they are becoming popular in sunny countries where cooking fuel is hard to come by. If you have enough time (and daylight), almost any food can be prepared in a solar cooker. It is also an inexpensive and reliable alternative for millions of people around the world who walk for miles to collect wood or use dung for fuel, creating dirty smoke indoors. They make it affordable to prepare nutritious foods, such as beans and whole grains, which require hours of cooking. And in places where people lack access to safe drinking water and become sick or die each year from preventable waterborne illnesses, solar water pasteurization is a lifesaver.

There are many different kinds of solar cookers, and because they are so simple to make, it's possible to experiment with different designs and different materials to find the one you like best.

Solar S'More Cup Test

Solar S'mores, like the traditional campfire treat, are made from warm marshmallows and chocolate sandwiched between two graham crackers.

Materials

Sunglasses
Styrofoam cups
Black paper
Aluminum foil
Chocolate Kisses
Graham crackers
Plastic knives
Bamboo skewers
Marshmallows

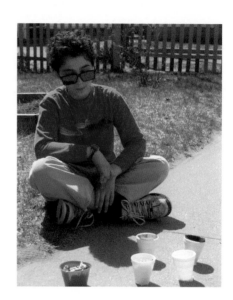

1. Put on your sunglasses. Take 3 cups per person. Line one with black paper and one with foil. Leave the third unlined.

2. Put a Kiss in each cup.

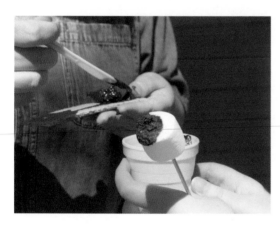

3. Note how long it takes for candy to melt in each cup. (You may have to poke it with the knife to see if it is softening up.)

4. Meanwhile, poke a skewer into the ground and put a marshmallow on the end of it.

5. With adult help, cook your marshmallow with a magnifying glass or plastic page magnifier. (See next page.) It may catch fire, so be careful!

6. Spread the melted chocolate on a graham cracker.

7. Take a second cracker and use them to slide the marshmallow off the skewer to make your S'More sandwich. Enjoy!

Cooking the Marshmallows

Simon Quellen Field's book *Gonzo Gizmos* has directions for a solar marshmallow roaster that uses a page magnifier (available from office supply stores) set into a cardboard box lid frame to collect heat from the sun. More properly known as a Fresnel (Fra-NEL) lens, this flat ridged plate was invented by French physicist Augustin-Jean Fresnel in 1822 for intensifying the beacon in lighthouses. By hollowing out a convex lens, cutting the curved surface that was left into rings and arranging them on a flat surface, Fresnel created a super magnifying glass that can extend a beam of light miles out to sea or make it easier to read a page of small print. It can also brown a marshmallow in less than a minute.

To cook the marshmallow the way my kids do, stick it on the end of a skewer which you can hold or poke into the ground. Position the Fresnel lens over the marshmallow until a bright dot of sunlight is focused on it; you may want to don some dark glasses. When the marshmallow is done, slide it off the skewer onto the chocolate-covered graham cracker and top with another cracker. MMMmmmm! Delicious.

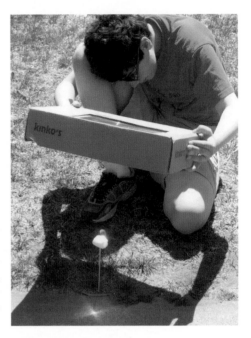

Solar Sticks

As you found out if you let your marshmallow cook too long, the sun is strong enough to actually set things on fire. Legend has it that in a battle in 212 BC, the Greek inventor Archimedes used mirrors to set wooden Roman warships ablaze. More recently, my son John took a small magnifying glass and used it to burn the names of his favorite Lego Bionicle characters onto sticks. I discovered these mysterious sticks, covered in what looked to me like strange messages, lying around our yard and thought they would make a great craft. So I asked him how he did it.

To make a Message Stick like John's, peel the bark off a nicely shaped, dry stick and set it down on the ground, in full sunlight, away from flammable grass or leaves. Take a small magnifying glass and position it so that a tiny dot of sunlight appears on the stick. The wood should begin smoking within a few seconds. (WARNING! Do not try this with the Fresnel lens or you will have flames, not smoke, within seconds.) Slowly move the magnifying glass along, using the spot of light to "draw" a line on the wood. Decorate your stick any way you like. You can use it to pass along secret messages, build a sculpture, create a mobile – anything under the sun.

Sources and Resources

Books

Cooking with Sunshine: The Complete Guide to Solar Cuisine with 150 Easy Sun-Cooked Recipes by Lorraine Anderson and Rick Palkovic

Gonzo Gizmos: Projects & Devices to Channel Your Inner Geek by Simon Field

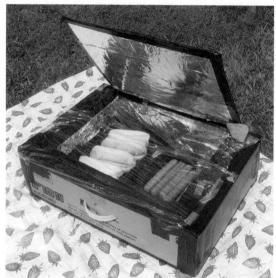

A "Pizza Box" type solar oven

Websites

Solar Cooking Archive
www.solarcooking.org

NASA solar hot dog cooker
http://tinyurl.com/3zvd5e

Solar Now Pizza Box Solar Oven
http://www.solarnow.org/printpizzabx.htm

Product Engineering Process class at MIT
http://web.mit.edu/2.009/www//experiments/deathray/10_Mythbusters.html
MIT students recreate Archimedes' mirror to set fire to a warship with TV's Mythbusters

The Telegraph

Inventions Old and New

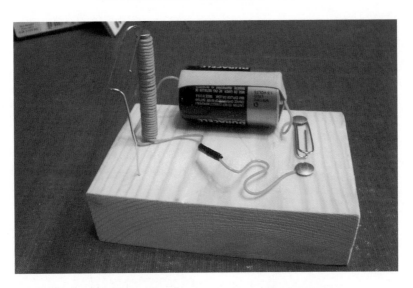

Do you remember life before iPods, Heelys, email and digital cameras? How about cell phones, Post-It Notes, and microwave ovens? For more than 150 years the Age of Invention has been changing our world, and there's no end in sight. Just think about how inventions have made communication easier:

- Before 1800s - News and personal messages take days or weeks to arrive.
- 1800 - Alessandro Volta invents the electric battery
- 1825 - William Sturgeon invents the battery-powered electromagnet
- 1830 - Joseph Henry uses an electromagnet to make a bell ring one mile away
- 1835 - Samuel Morse invents the telegraph -- an electromagnet that receives pulses of current in Morse Code
- 1876 - Alexander Graham Bell, trying to improve the telegraph, invents the telephone

And since then radio, television, cordless phones, cell phones, the Internet and WiFi have remade the way we gather and share information over and over.

Of course, lots of inventions just make life a little safer, easier, or more enjoyable. The safety pin was invented by Walter Hunt in 1849 to pay off a $15 debt. (The lender paid Hunt $400 for the invention, and made a mint.) Composer Richard Rogers' wife Dorothy hated scrubbing toilets and came up with the flushable Jonny Mop. And in 2003, 6-year-old Miranda Evarts spent a restless night inventing the card game Sleeping Queens.

Inventors don't need formal training. Samuel Morse was a portrait painter. Movie star Hedy Lamarr invented a torpedo guidance system that was decades before its time. And in 1922, a 14-year-old Idaho farm boy named Philo T. Farnsworth sketched out plans for the first video screen on his high-school science teacher's blackboard. You don't even need a fancy workshop. Just ask Roger Adams, who made the first Heely out of a Nike sneaker using a hot butter knife to cut out the heel and insert a skateboard wheel bearing!

Telegraph Directions

You can get a taste of inventing by making a model of Morse's telegraph. It works because sending an electric current through a wire coil creates a magnetic field, and placing an iron core inside the coil turns it into a temporary magnet. When you tap the telegraph key, you close an electric circuit that sends current to the electromagnet. The metal sounder is attracted by the magnetic force and clicks against the magnet. (One click for a dot, two clicks for a dash.) Releasing the key breaks the circuit, and the sounder bounces back up.

Materials:

Base – An oblong block of wood, corrugated cardboard or Styrofoam.
Wire - Thin insulated electrical or magnetic wire. Strip about half an inch of insulation off each end where the wire is connected to other metal parts.
Telegraph Key and Sounder – Two flexible pieces of iron-based metal, such as large paper clips.
Fasteners - Brass thumbtacks or iron-based screws.
Power source - Flashlight battery with a rubber band around the ends to hold the wire, or a solar cell or wind-up generator.
Iron core – A 3-inch nail works great.

1. Make the electromagnet by inserting the nail into one end of the base. Leaving 6-10 inches of wire at both ends, neatly wrap the wire around the nail from bottom to top and back down again (about 80 turns of wire all together).

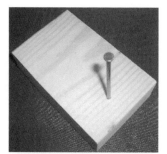

2. At the other end of the base, insert a fastener near one side to attach the key. Open a paper clip by pulling the two loops apart a little bit. At the bend, slip the smaller loop over the fastener so that the larger loop sticks up at an angle. Push down the bigger loop, and where it touches the base, insert another fastener. The key should only be touching the second fastener when it is pressed down.

3. Connect one wire from the electromagnet to one fastener and one to the other.

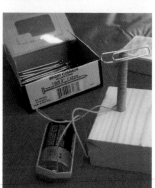

4. Cut one wire in the middle and strip the ends. Attach them to the power source. Test your electromagnet by tapping the key to close the switch.

5. To make a sounder, bend the other paper clip into an L shape and straighten the shorter loop. Insert the straight end into the base so that the remaining loop is barely touching the top of the nail. Adjust so that the loop clicks against the head of the nail when the sounder is tapped.

6. If you make another telegraph setup and wire them together you can send messages back and forth. (Make sure the key is down on the receiving end.)

Learn Morse Code

Morse Code is a way of representing the letters of the alphabet using short and long sounds or signals, called "dots" and "dashes." Telegraph operators tapped out dots and dashes on their telegraph keys, and the signals were transmitted over electrical wires to another operator who listened to the dots and dashes and translated them back into letters and words. When the radio was invented the dots and dashes could be sent over the air waves instead of wires. Until very recently you had to know Morse Code to get a radio operator's license.

The original Morse Code invented by Samuel Morse used spaces as well as sounds, and came to be called American Morse Code. International Morse Code shown on the chart here eliminated the spaces and changed the order of dots and dashes.

Getting the hang of tapping out signals of different lengths may take some practice. Here is a guide:

1. One dash = three dots.
2. The space between a dot and dash within a letter = one dot.
3. The space between letters in a word = three dots.
4. The space between words = seven dots.

You can practice translating Morse Code signals at the Cryptokids section of the U.S. National Security Agency's website (www.nsa.gov/kids).

A	.-
B	-...
C	-.-.
D	-..
E	.
F	..-.
G	--.
H
I	..
J	.---
K	-.-
L	.-..
M	--
N	-.
O	---
P	.--.
Q	--.-
R	.-.
S	...
T	-
U	..-
V	...-
W	.--
X	-..-
Y	-.--
Z	--..

Kid Inventors

Kids are full of ideas, and some of them turn out to be great inventions. Chester Greenwood of Maine came up with the idea for earmuffs while out skating in 1873, when he was 15 – and later made a fortune selling them to U.S. soldiers during World War I. The Popsicle was accidentally created by 11-year-old Frank Epperson when he left a sugary drink with the stirring stick still in it on his back porch during a cold snap in 1905. And in 1963, Tom Sims built the first snowboard in his eighth-grade shop class. So get thinking – you'll never know where it'll lead!

Sources and Resources

Books

The Kid who Invented the Trampoline: More Surprising Stories About Inventions by Don Wulffson
Kids Inventing: A Handbook for Young Inventors by Susan Casey
Inventions book and kit by Science Wiz

Websites

Smith College Ancient Inventions
www.smith.edu/hsc/museum/ancient_inventions
Student-made replicas of historical artifacts, including a battery from 250 BCE.

National Inventors Hall of Fame
www.invent.org
Nearly 400 inductees from the 1700s to today such as razormaker King Gillette.

National Gallery for America's Young Inventors
http://nmoe.org/gallery
Comic strips explain how each inductee came up with their award-winning idea.

MIT Invention Dimension
http://web.mit.edu/invent/invent-main.html
Inventor of the Week and games like "Which Came First."

Invention at Play
www.inventionatplay.org
Shows how fooling around leads to new discoveries with an online exhibit of toys and interactive puzzles, doodling, collaborative stories, and more.

The Great Idea Finder
www.ideafinder.com
Suggest something– sugarless chocolate, hair straightening shampoo, or a tool to make your hamster quiet at night –that YOU would like to see someone invent for the Idea Wish List.

US Trademark and Patent Office Kids Page
www.uspto.gov/go/kids
Walks you through the steps of protecting an idea, plus fun stuff like the Trademarked Sounds page.

Robot Hand

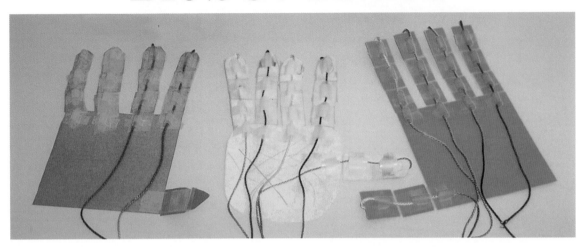

The world of robots is divided into two camps: those that look like machines, and those that look like people. In the Star Wars movies, for example, you have the fire-hydrant-shaped R2D2 and his droid companion C3PO, the gold-plated British butler. The Roomba, a self-propelled robot vacuum cleaner, has been described as "an oversized hockey puck," while kids go nuts for the humanoid Robosapien, a toy designed by the developer of biomorphic robotics. You could argue that both types are cute, so why would scientists bother making robots look human?

The answer is that humans – and other living creatures – move in ways that machines may find useful. For instance, researchers are working on lobster and lamprey eel robots that might one day be used to explore the ocean floor. Experimental robot snakes that climb poles and swim are creepily realistic. Other "biomimetic" robots mimic dogs, cockroaches and elephant trunks.

Of course, most of the robots used in the home and in businesses today are of the plain machine variety. As Roomba-maker Helen Greiner explains, that's because wheels and tank treads are still more efficient than legs in crossing long distances. Greiner's company iRobot (named after the visionary Isaac Asimov novel)

once worked on insectlike devices to be used for planetary exploration, before NASA decided to give the Mars Rovers a tractor design. But some scientists still believe there's a need for human-like robots that can go where people go and do jobs that humans do. In fact, crude robot hands and arms have been used for years in factories, underwater, and in space.

Designing a robot hand that works as well as a human hand is not an easy task. Probably the most advanced model to date comes from the Shadow Robot Company in London, England, whose customers include NASA, Cambridge University and Lego. It uses 40 artificial "air muscles" to perform 24 movements, including picking up delicate objects, unscrewing caps, and scratching a person's head with its "fingernails." But even the simple cardboard robot hand you can make from the directions below bends and straightens its fingers in a very lifelike way.

No matter how basic or complicated, a robot hand and a real hand work the same way. Chords known as tendons move the fingers when they are pulled by the muscles in the arm. You can use the same principle to build a simple cardboard "robot hand" that uses strings as tendons. You provide the muscle-power.

Robot Hand Directions

Materials:

1 sheet of card stock (stiff postcard-type paper) or other thin, stiff cardboard
clear tape
2-3 drinking straws
5 pieces of string about 10 inches long

1. For the palm of your robot hand, cut out 4-inch square of cardboard.

2. For the fingers, cut out four rectangles 3/4 inch wide and 3 inches long. Cut out a rectangle one inch wide and 2 inches long for the thumb. Draw lines to divide each finger and the thumb into sections 1 inch long. These are the joints.

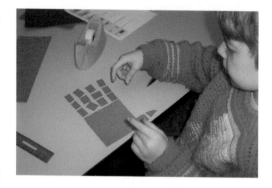

3. Lay out your robot hand by lining up the fingers along the top of the palm and the thumb on the side.

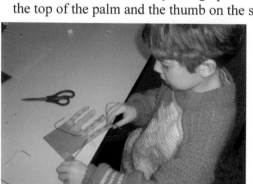

4. Cut the fingers and thumb into sections along the joint lines. Reassemble, leaving a little space between each section.

5. Use tape to connect the finger sections to each other and to the palm, making sure to keep a space between each section. Tape front and back for extra strength.

6. Cut the straws into 14 pieces about 1/2 inch long.

7. On the inside of the hand, tape one piece of straw onto each finger section and onto the palm below each finger. Trim the tape if needed so it doesn't hang over the edge of the straw.

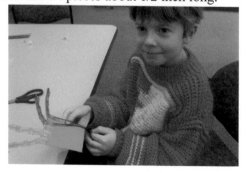

8. Thread one string through the straws for each finger. (A crochet hook will help you pull the string through the straws.) Tape the end of the string over the tip of the finger, leaving the lower end hanging loose.

9. Pull the strings to curl the fingers inward. With a little practice you'll be able to make your robot hand point or pick up objects with amazingly life-like gestures.

An Interview with Roboticist Daniel H. Wilson

Daniel Wilson looking serious

What's the difference between an appliance and artificial intelligence? According to roboticist Daniel H. Wilson, a machine is considered a robot when it can:

- sense the environment,
- think about what to do, and
- act in the physical world.

By that definition, even a smoke alarm is a type of AI. And it's not alone.

"We are surrounded by all these machines that are making decisions without human intervention," Wilson says. "Robots don't even have to move to be robots. Instead of moving themselves, they can send commands to the real world."

Wilson's book *How to Build a Robot Army* suggests ways to turn robots found in homes or laboratories into your personal defense team. Maybe you don't want to equip your Roomba vacuum cleaner into a mobile flame thrower, but how about adding an infrared navigational sensor to your FlyTech Dragonfly (cousin to Robosapien) and creating a micro air drone that can scope out the woods at night from above?

Wilson likes using humor (his first book was called *How to Survive a Robot Uprising*) to let the public know what's going on in the world of robotics in a fun way. He doesn't really believe robots are a menace to humankind. Far from it.

"That's a theme in robotics," he says. "Respecting human contact."

In fact, it turns out people can become attached to their mechanical friends (as any kid with a Tamagotchi or a Furby can tell you). Sony's AIBO, an electronic dog that can recognize its owner's face, is used in senior citizen homes to give residents the benefits of real live pets without the responsibility.

An experimental mini-robot called the Keepon being developed at Wilson's university, Carnegie Mellon, actually makes people want to interact with it. Resembling a stack of tennis balls with googly eyes, the Keepon can follow a person's eyes or bop around in time with music or movement in its environment. Wilson made a video for Carnegie Mellon that shows him taking Keepon out for a drive and snuggling up to it.

Being a scientist, however, it's the technology behind Keepon that interests Wilson.

"That's the thing about robots," he says. "You always find a trail of technical papers following behind a robot, no matter how cute."

(Adapted from an article originally published in the Albany Times Union.)

Sources and Resources

Books

Ultimate Robot by Robert Malone
A survey of the history of robots from tin toys to sci-fi to military applications.

Websites

NASA Robotics Alliance Project
http://robotics.nasa.gov
For students, engineers and organizations

Robots.net
http://robots.net
News on personal and industrial robotics and competitions

ROBOT magazine
www.botmag.com
Consumer, toy and hobby robot products and has a long list of robot links

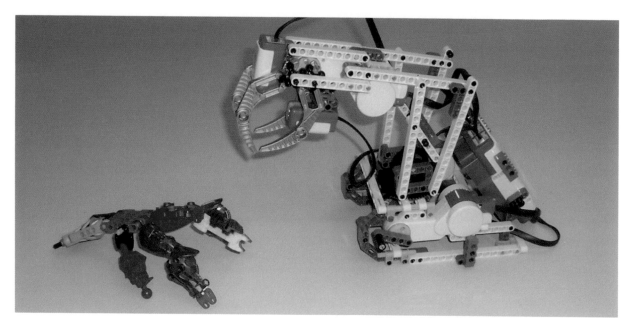

Robotic hands made from Lego Bionicle parts and Lego Mindstorms NXT

TOYS AND GAMES

Mancala

A Family of Count and Capture Games

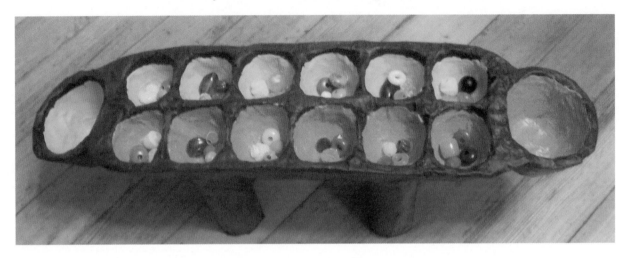

Board games are a favorite pastime around the world, and one of the oldest is the game of mancala. "Mancala" means "to move" in Arabic, and is believed to have started in Egypt more than 3,000 years ago. Many variations of this two-person game are played today in Africa, the Middle East, Asia, and the Caribbean, especially in Muslim areas. Like many popular board games, mancala is easy to learn, but good players know how to use strategy to help them win.

In English mancala is sometimes called "Count and Capture," and math and logic can help you figure out how to move. It's possible to plan many turns ahead, if your opponent also uses strategy. In fact, far from being a children's game, mancala exists in many different versions with varying degrees of difficulty, from simple to complex. While the typical mancala board you can buy has two rows of six holes, other versions use three, four or more rows. There are also different rules about the numbers of pieces in each hole, as well as how to move and capture pieces.

Like the rules for the games, mancala boards themselves can be simple or elaborate. Archeologists have found mancala games carved into rocky buildings and public squares. Sometimes they are dug into the dirt. On the opposite extreme, many beautiful boards are carved of wood in the shape of boats or carts, animals like fish or crocodiles, and many have legs, stands, or human figures holding them up.

Mancala Game Trivia

In West Africa, the holes in the board are called *warri* or *awari*, which means houses, and the game is known as *wari*. In Nigeria it is called *adi*, after the type of seeds used as game pieces. The Indonesia, where it is considered a girl's game, its name *congklak* comes from word for cowrie shells. The Sulawesi call the game *mokaotan*, *aggalacang* or *nogarata* and are forbidden to play except when mourning the death of a loved one.

Mancala Board Directions

You can make a mancala board with just an egg carton and 2 cups, but if you prefer a fancy model and you're not ready to tackle woodcarving, you can make a sculptured board with paper maché.

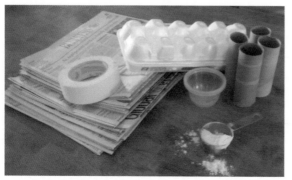

First you'll need to make an armature, or framework, to hold the paper maché. For our board we used an egg carton (Styrofoam or plastic won't soak through) and added cardboard tubes for legs and fruit cocktail snack cups for stores on the ends. Masking tape was used to hold the pieces together and to cover over the cardboard.

Now you're ready to make the paper maché. Tear newspaper (or other soft, non-glossy paper) into strips 1-2 inches wide. For the adhesive, you can use white glue thinned with water, wallpaper paste (non-fungicide), or mix up your own with flour and water. The recipe below makes enough for 4 layers on one mancala board.

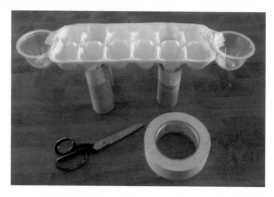

Paper Maché Paste

1. Boil 3 cups of water in a large saucepan.
2. Sift 1/4 cup of flour into 1 cup of cold water. Stir until all lumps are dissolved.
3. Add the flour mixture to the boiling water. Continue boiling, stirring constantly for two or three minutes until the mixture thickens. Add 2-3 tablespoons of salt to prevent mold.
4. Let cool before using. Store in an airtight container in the refrigerator.
5. To begin covering your armature with paper maché, take a strip of paper by one end and drag it from top to bottom through the paste. Then hold the strip up over the container and use two fingers to squeegee off excess paste. Apply the strip to your armature, smoothing down with your fingers. Completely cover the

armature, no more than 2 or 3 layers deep. Criss-cross the layers for added strength. Let dry before adding more layers or painting. Use acrylic paint and/or gesso to seal the paper maché from moisture.

For game pieces, you can use beans (dried or jelly), shells (snail or macaroni), seeds, paper clips, pebbles, coins, buttons, marbles, or any small object.

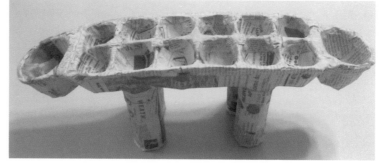

How to Play Mancala

Here's a version using a board with two rows of six holes, a cup or "store" at each end, and four playing pieces in each hole to start.

Set up the board by putting it between the players. Put four pieces in each hole. The row closest to you, and the store to your right, are yours. Captured pieces go in your store.

1. To start, pick up all the pieces in any hole on your side of the board. Going counter-clockwise, drop (or "sow") one piece in each hole until you run out.

2. When you come to your store, drop a piece in. Skip over your opponent's store.

3. If your last piece falls in your own store, go again.

4. If your last piece falls in an empty hole on your side, capture that piece and all the pieces in the neighboring hole on your opponent's side.

5. Take turns moving until all the holes on one side of the board are empty.

6. The pieces left on the other side of the board go into that player's store.

7. Count the pieces in your store. The player with the most pieces wins.

Mancala Strategy

There are four goals to keep in mind when making moves in mancala. (And it's a social game, so if you forget, your audience will remind you!) If you choose moves that accomplish these goals – in order – you will have the best chance of winning.

First, try to make a move that will give you another turn. That way you can keep going.

Second, make a move that will put the most pieces in your cup.

Third, make a move that will protect your pieces from your opponent, for instance by moving your pieces away from an empty hole on the other side.

Fourth, if you can't make any other moves, set up a move for your next turn. You can do this by getting pieces within one jump of your cup, for example.

Sources and Resources

Books

Games: Learn to Play, Play to Win by Daniel King

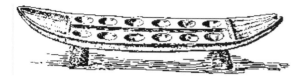

Websites

The British Museum
http://members.aol.com/HyadesSoft/mancala/museum/index.html
Collection of mancala boards

University at Waterloo
http://www.gamesmuseum.uwaterloo.ca/VirtualExhibits/countcap/pages/index.html
Virtual museum of games, including mancala

Mancala Snails
http://www.lilgames.com/mancala_snails.shtml
Online computer version you can play to sharpen your skills.

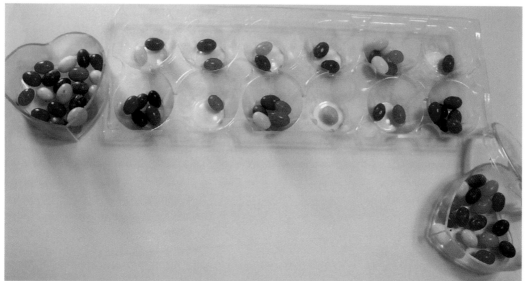

A mancala board made from a plastic egg carton, plastic heart-shaped stores, and jelly beans

Boomerangs

The Science of Flight

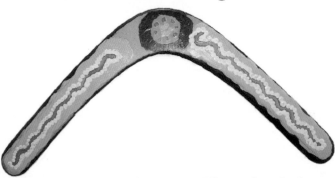

Early humans around the world came up with the idea of throwing sticks made of wood, bone and even mammoth tusk for hunting more than 20,000 years ago, but only the Aborigines of Australia made one that came back. And from the start, the boomerang was as popular for play and competition as for practical use. Today athletes from 25 countries meet for world championship boomerang tournaments to test their skill in accuracy, distance, speed, and maximum time aloft. The top distance ever thrown was 238 meters, and John Gorski of Ohio holds the record for keeping a boomerang in the air before catching it -- 17 minutes. Of course, for many other enthusiasts who like to play games or practice trick catches, the sport of boomerang throwing is just a lot of fun.

According to Aborigine tradition, the boomerang was invented during the Dreamtime, when creator ancestors formed the landscape of Australia. The story goes that Toonkoo was out hunting when he chucked a spear up to the sky, trying to hit Darama, the Great Spirit. Darama caught it, bent it and chucked it back, turning it into a boomerang. In reality, the boomerang was probably an accidental discovery that was then improved by Aboriginal hunters until they came up with the familiar flat "V" shape. Modern boomerangs come in many different shapes and sizes, depending on whether you're looking for longer or higher flight, more accurate returns, or stability in windy weather.

What makes the boomerang work is a combination of several scientific principles that are complicated to explain, but that you can see every day in action when you look at a bicycle, an airplane or a Frisbee. First, the bend of the boomerang and the way it's thrown causes it to spin as if the arms were the spokes of a wheel, giving it stability when it flies. (Think of a how a bicycle stays upright when the wheels are turning, but will fall over as soon as you stop unless you put your foot down.) This is called "gyroscopic precession." Second, the wedge-shaped boomerang's arms are airfoils, like the wings of an airplane. As the boomerang flies, air has to move faster over the top of the arms, which have a bit of a hump, to keep up with the air flowing underneath, which is flat. The faster-moving air molecules are spread further apart, lowering the air pressure. The denser, more compact air molecules from below are then able to lift the boomerang up. This is known as "aerodynamic lift," or Bernoulli's Principle. (You can test it by taking a strip of paper, holding it just under your lips, long end dangling down, and blowing across the TOP of the piece of paper. What happens?) Gravity and air friction also act on the boomerang to slow it down so that it eventually hovers in flat for an easy catch like a Frisbee.

The Resources page will lead you to more information on Aborigine art, boomerang science, and techniques and games to that will keep you coming back to the ancient sport of boomerang throwing.

Boomerang Directions

You can make a simple cardboard boomerang to try indoors. Experiment by making different sizes, rounding the tips, etc. to see how the boomerang's flight is affected. Then decorate your boomerang in a traditional Aboriginal style.

Materials

Stiff, lightweight cardboard
ruler
pencil or pen
scissors
stapler
permanent markers

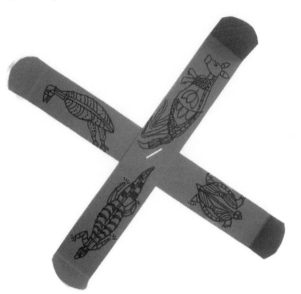

1. Measure and cut two 1-inch strips of cardboard, about 8 inches long.

2. Fold up the tips of the strips, about an inch from the end.

3. Staple the strips together in an X shape.

Aborigine Art

Clans from different parts of Australia developed different styles of art. **X-ray paintings** have been found on caves and rocks in the western part of northern Australia going back to around 2000 B.C. They have also been painted on tree bark. Not only is the silhouette of the animal or human shown, but also its backbone, ribs, and internal organs. Sometimes the interior is filled with cross-hatching, which is a design of diagonal lines or diamond patterns. X-ray paintings are usually white, with red or yellow details.

Dot paintings began as sand paintings created by clans of people who moved from place to place in the desert. They would be created on a central site using seeds, flowers, sand, stones, feathers, and other natural substances. During the "painting" clan elders would sing to pass along tribal knowledge to younger members of the clan. Incorporated into the paintings are symbols for footprints, waterholes and pathways that allow them to be read as a map.

Both styles of painting are popular with Aboriginal artists today. Modern artists often use bright colors, as well as the natural earth colors used long ago. You can see these styles used as decoration on all kinds of Australian objects, from boomerangs to didgeridoos (wind instruments made from hollow tree branches) to clothing and accessories.

How to Throw a Boomerang

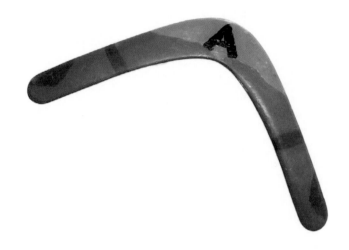

To throw, pinch one arm of your boomerang between your thumb and first finger and hold it vertically (straight up and down), not horizontally like a frisbee, with the folded ends towards you. Flick your hand forward like you're knocking on a door. Giving it a good spin is more important than throwing it hard. If your boomerang doesn't return, you can try tilting it to the right or left.

For outdoors you'll need something heavy enough to stand up to a bit of a breeze. Colorado Boomerang (see Resources) has a Paint Your Own Boomerang kit that comes with an unfinished hand-made birch boomerang, paint, a brush. They're recommended for ages 10 and up, but I've used them with younger kids under careful supervision. Make sure you know the rules (one thrower at a time, leave plenty of open space around you, and *Duck!* if you're not sure which way it went) before practicing with a real 'rang.

Sources and Resources

Books

Big Rain Coming by Katrina Germein, illustrated by Bronwyn Bancroft

Aboriginal Art & Culture by Jane Bingham

Boomerang: How to Throw, Catch and Make It by Benjamin Ruhe and Eric Darnell

What Makes a Boomerang Come Back: How Things in Sports Work by Sharon L. Blanding

Websites

Indigenous Australia from the Australian Museum
www.dreamtime.net.au/

Aboriginal Australia Art & Culture Centre
www.AboriginalArt.com.au

Colorado Boomerangs
www.coloradoboomerangs.com
A catalogue with good tips on throwing and a "Paint Your Own" kit for kids.

Flipbooks
The Art of Animation

From the earliest pen-and-ink novelties to the most sophisticated computer-generated full-length features, animated films have always been a cross between art and magic. Of course, they're part science too: it's the split-second afterimage in our brains (known as "persistence of vision") that makes us think a speeding series of still pictures is actually a scene in motion. But it's the animator's tricks, plus the ability of great animators to "act" through their imaginary characters, that really makes animated images come alive.

The flipbook dates back to 1868, when the invention of photography inspired all kinds of animation devices (see the Resources page for some examples). It is simply a pad of drawings where an image changes shape or position slightly from page to page. When the pages are flipped quickly, the image appears to move. Live-action films work exactly the same way, except that a series of photographs are used instead of drawings, and the image is projected onto a TV or theater screen. The big difference is that it can take up to 24 images to make one second of film – that's 129,600 drawings for an average 90-minute full-length feature!

As a young artist I learned some of those tricks from two independent filmmakers who are still creating hand-drawn animation today. Working for Michael Sporn (you can see his work at www.michaelspornanimation.com) as an "in-betweener" on his Oscar-nominated adaptation of the children's book *Dr. DeSoto* showed me how speed and rhythm reveals a character's personality. And author, artist, and historian John Canemaker – winner of the 2006 Academy Award for Best Animated Short – taught me that good animators are good observers, recreating the world using only line and color.

Next time you watch a great hand-drawn film see if you can pick out some of the animators' tricks. My favorites: Winsor McKay's silent hit *Gertie the Dinosaur*; anything by Hayao Miyazaki, especially *Kiki's Delivery Service* and *Spirited Away*; *The Triplets of Belleville* which combines hand-drawn and computer-generated images; old Bugs Bunny and Road Runner shorts; and Disney classics like *Pinocchio*, *Jungle Book*, and *Aladdin*. Fabulous drawing, amazing characters – magic, every one!

Flipbook Directions

Flipbooks are a great way for beginning animators to create instant movies, no fancy cameras or special software needed.

Materials

Paper: A small memo pad (about 3 X 4 inches) that is glued or stapled at the top (not wirebound) makes a great flipbook. I like to use graph paper pads from the French company Rhodia or mini composition notebooks; the lines help position the drawings. You can also make pads from 30-40 sheets of looseleaf paper cut to size and stapled. Using index cards for covers will make it easier to hold and flip. Reinforce the binding with heavy tape if needed.

Pen: A dark felt-tip pen is best, but make sure the ink doesn't show through the paper; mistakes can be fixed with a white correction pen.

1. Use only the lower part of the page.

2. Starting on the last page, draw a simple shape.

3. Now put the next page down so that you can see your drawing through it.

4. Copy your first drawing, but in a slightly different position.

5. Continue putting down new pages and moving your drawing. Whenever you want to check how it's coming out, just flip it.

How to Flip

Hold the pad at the top and flip it from the bottom, like this: Put out your left hand (or if you're a lefty, your right hand), palm up. Place the pad in your hand so that the stapled or glued edge is at the top, closest to your fingertips and bend your fingers over the top of the pad. With the thumb of the other hand, pick up all the pages in the pad and flip from back (last page) to front (first page).

Animation Tips

Once you've got the hang of moving your drawing around, try some animators' techniques to make it even more "lifelike." The secret? Exaggeration. Take squash and stretch. If you want to make a rubber ball bounce, stret-et-et-ch-ch it out as it goes down and back up. As it hits the ground, s q u a s h it almost flat for a second before it recovers and starts its return. Or try using anticipation. Before your character runs off to the right, have him lean back to the left. Then there's follow-through. If you draw a girl spinning around, make her pony-tail, her skirt -- anything that's loose -- lag behind the rest of her body a second. Watch someone acting out the motion, or try it yourself in a mirror, to see what I mean.

Look at how the cat in the flipbook pages below (go top to bottom) stretches and squashes, while its tail follows-through as it swishes through the air.

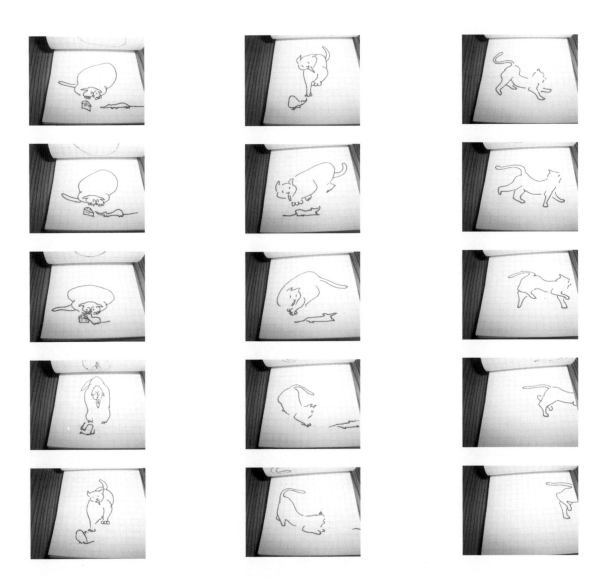

54

Sources and Resources

Books

The Animator's Survival Kit by Richard Williams

Cartoon Animation by Preston Blair

Websites

Larry's Toon Institute
http://tooninstitute.awn.com
Animation World Network's Larry Lauria teaches bouncing balls, character construction, timing, posing and learning how to "thumbnail," or plan out, a scene.

The Hunting of the Snark by Michael Sporn

Karmatoons
www.karmatoons.com
Illustrated teaching notes from Bugs Bunny artist Doug Compton.

Acme Animation
www.acmeanimation.org
Printable instructions for free, and feedback from working professionals for paying members.

Stop Motion Animation
http://stopmotionanimation.com
Forums on technique, and good links.

StopMoShorts
www.stopmoshorts.com
Complete "puppet training" challenges, plus interviews tutorials, and clips from classic films.

Amazing Kids Animation Station
www.amazing-kids.org
Flash Animation tutorial and a showcase to display videos.

Flash Kids' Corner
http://animation.about.com/od/kidscorner/Flash_Kids_Corner.htm
Flash lessons plus free computer animation software you can download
(http://animation.about.com/od/referencematerials/a/freesoftware.htm)

Optical Toys Exhibit
http://courses.ncssm.edu/gallery/collections/toys/opticaltoys.htm
Zoetropes, Magic Lanterns and more at the NC School of Science and Mathematics.

Flipbook.info
http://www.flipbook.info/index_en.php
Historical flipbooks, including video clips of some antiques (translated from the French).

SACRED ART

Arctic Inuksuk

Life in the Far North

The geography of a place – its location, landscape, climate, natural resources, plants and animal life – has a big effect on the people who live there. As Jared Diamond's book *Guns, Germs and Steel* showed, societies can become conquerors or the conquered simply because of what crops can be grown in their region. And nowhere is geography's effect more noticeable than at its most extreme: atop mountain ranges, across vast deserts, on remote islands and in the barren Arctic tundra.

Look at the top of a globe or at a circumpolar map and you'll find the North Pole in the center of the frozen Arctic Ocean. Surrounding it is the Arctic tundra (from the Finnish *tunturia*, or treeless plain) of Alaska, Canada, Greenland, Scandinavia and Russia. The tundra is cold (between -90 and 50 degrees F), windy, dry and mainly flat. In winter the sun barely rises, although in the short growing season the daylight lasts almost 24 hours. But because there's just a thin layer of soil where plant roots can take hold above the permafrost, only low shrubs, moss and grasses flourish there. The Arctic is home to caribou (reindeer), hares, wolves, and polar bears, as well as ravens, loons and other migratory birds. Mosquitoes, flies, and bumble bees thrive in the summer, and the rivers hold cod, salmon, and trout.

Humans came to Siberia around 30,000 years ago, and the settlers who later crossed the Bering Strait into North America are the ancestors of today's Inupiat, Yup'ik, Aleut, Athabaskan and Inuit. With trees and metals scarce, Arctic peoples learned to use animal skins, bones, and teeth, different types of stone and even snow for tools, clothes and building materials. Traditional Arctic styles of clothing (parkas or anorak jackets, mukluk/kamik boots), shelter (igloos) and transportation (dog sleds and kayaks) are not only still popular,

they've also spread to other parts of the world as well.

Another unique Arctic creation which has spread to other cultures is the inuksuk, found in gardens and in many parts of the world and fast becoming a symbol of Canada.

Inuksuk or *inukshuk* means "thing that can act in the place of a human being" in the Inuit language. It is a stack of stones ranging from knee high to bigger than an adult, used as landmarks to point out hunting trails, fishing spots, and food storage caches, and as memorials for friends or ancestors. Some are in the shape of a doorway through which the next inuksuk along the path can be seen. Sometimes long strands of moss were attached to blow in the wind and frighten caribou herds into stampeding towards waiting hunters. Many are built in the shape of a human, with legs, arms and a head.

The geography of the Arctic is changing. Global warming is melting snow and sea ice, and the permafrost has started to thaw. And as the climate, landscape and weather patterns change, the lives of the plants, animals and people there are changing too. Looking at the geography of the Arctic is one way of finding out what those changes may mean for its inhabitants, and the rest of the world too.

Inuksuk Directions

Making an inuksuk takes patience. Carefully balancing the rocks is key. For a medium-sized inuksuk, you can wedge pebbles where needed to level out the stones. To make a tiny permanent inuksuk for your shelf, arrange some landscape stones or favorite rocks and secure with tacky glue.

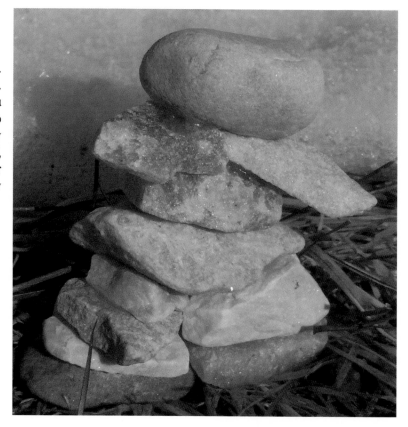

The Game of Storyknives

In Yup'ik families, fathers traditionally carved decorative storyknives of ivory for their young daughters, who used them to play an outdoor circle game. The storyknives had long handles in the shape of a fish or bird head, with designs along the blades. The game was played around a clear area of snow or mud. The group of children would squat in a circle and take turns telling stories, which could based on real life or legends. The storyteller would illustrate the action using special agreed-upon symbols to represent people, houses, trees, animals, and so on. Symbols often differed from village to village. Before the figure was mentioned it had to be drawn, and when it exited the scene it was erased. Stories usually ended with a standard saying, such as "That's all we know." Then the next person in the circle would take a turn.

You can try a variation of storyknives using white plastic knives decorated with black permanent markers. Find a suitable spot outside or fill a tray with sand or Crayola Model Magic clay. (You can also place a whiteboard on the floor and draw with erasable markers.) If you have trouble thinking up your own story, practice using a fairy tale you know, such as Goldilocks and the Three Bears.

Track through woods

Man, woman, baby

House **Bed**

Sources and Resources

Books

The Inuksuk Book and *Make Your Own Inuksuk* by Mary Wallace

People of the Ice and Snow, Time-Life Books

Inuksuit: Silent Messengers of the Arctic by Norman Hallendy

Tundra Mouse, A Storyknife Tale by Megan McDonald

The Three Snow Bears by Jan Brett (an Inuit retelling with related coloring pages at www.janbrett.com)

Websites

Inuit Life in Nunavit
http://kativik.net/ulluriaq/Nunavik/index.html
A fun website created by students of the Ulluriaq school

Alaska History and Cultural Studies
www.akhistorycourse.org
There is a section on the physical, environmental and human geography of the region

National Oceanic and Atmospheric Administration Arctic Research Program
 www.arctic.noaa.gov/aro
A good place to find information on Arctic change.

Canada's Polar Life from the University of Guelph
www.arctic.uoguelph.ca/cpl/index.htm
Legends and scientific information about Arctic plants and animals

> Inuktitut Animal Names (Audio Files)
> www.arctic.uoguelph.ca/cpl/Traditional/traditional_frame.htm

Inukshuk Video Clip – Historica Minutes
www.histori.ca/minutes/minute.do?id=10210&sl=e

Inukshuk Creator online game
www.canadianencyclopedia.ca/images/inukshuk/game.html

Tibetan Sand Mandalas
Buddhism Expressed Through Art

High in the Himalaya mountains, Tibet became an independent kingdom in the seventh century, when the great king Songtsen Gampo defeated the armies of nearby China under the Tang dynasty. As his empire grew along the trading route known as the Silk Road, the king was introduced to Tibet's southern neighbor, India. Liking what he saw, Songtsen Gampo borrowed the Indian system of writing, laws and its religion, Buddhism for his own country. Siddhartha Gautama, the Buddha, was born in India and started a faith based on peace and right action. Although Tibet already had a religion of nature worship called Bon, King Songtsen Gampo hoped that Buddhism's nonviolent teachings would help bring stability to his government. The two faiths began to mingle and make themselves felt in every aspect of Tibetan life.

For instance, new babies were named by the lama, the Buddhist priests, and the dates for important events like trading caravans were determined by the lamas according to the stars. But when the lamas couldn't give Tibetans the answers they wanted, they turned again to the older religion. In the movie *Himalaya*, which takes place in a Tibetan region of neighboring Nepal, an old chief gets a new name for his grandson so that the mountain gods will not be jealous of his highborn family and destroy him.

Tibetan Buddhist monks become masters of many native art forms. One is a type of musical chant called throat singing or multiphonic singing, where they produce three notes of a chord at the same time. They learn to play traditional instruments including 10-foot long *dung-chen* horns, drums, bells, cymbals and *gyaling* trumpets. And some become wonderful painters of murals and sand mandalas.

Circular mandalas, or *kyilkhors*, are used in Buddhist ceremonies and meditation. They can be made out of sand, crushed flower petals or jewels, or even sculpted out of yak butter. Every line, shape and color has a meaning: a blue thunderbolt symbolizes compassion, a peach stands for the sense of taste, and a flowing silk scarf represents touch. Following the symbols inward from the edge of the circle to its center, Buddhists find within the mandala the seed of inner enlightenment. It can take three years for a monk to memorize the different mandalas, learn about meaning of their symbols, and master the technical skill needed to create them. Up to eight feet in diameter or larger, a mandala can take several weeks to complete. Grain by grain the sand is poured onto the design base using a pair of thin metal funnels called *chakpus*. Holding one sand-filled *chakpu* in position, the monk rasps its mate across the top, creating vibrations which can be

adjusted to shake the sand out in a stream or a trickle. When finished, the mandala is ceremoniously swept up and deposited into the nearest body of flowing water -- a reflection of the fact that nothing in life is permanent.

In the 1950s, China took control of Tibet, and the country's spiritual and political leader, the Dalai Lama, was forced to flee. Happily, the thousands of Tibetans now living in exile around the world are preserving the art, religion and culture of their ancient land.

Sand Mandala Directions

Unlike real sand mandalas, our small-scale version will be permanent, ready to be displayed on a shelf or hung on a wall. You can use actual mandalas as your inspiration or create your own design. Try to keep in mind the symmetry, interlocking patterns, and contrasting colors Tibetan monks use to express the Buddhist philosophy of wisdom, compassion and peace.

Materials

Colored sand (a multi-pack containing small bags of several colors, enough for 6-8 mandalas, costs only a few dollars)
White glue
Paper plates, one for each color sand and one for the glue
Narrow, pointed paint brushes
Heavy cardboard or wooden base
Plastic straw, cut on the diagonal at one end to make a scoop

Use a sharp pencil, sketch in the lines of your design. Don't make the spaces you need to fill too small, but try to make your design interesting and lively. Flowers, trees, and other shapes from nature as well as geometric shapes are all traditional. Look at the details in the Tibetan mandala photos to see how these objects are stylized. And don't worry too much about the lines – they'll all be covered up by the sand.

When your drawing's done, work as the monks do from the center outward. Pour some glue onto a plate and dip a small paint brush into the glue, wiping off any drips. Carefully brush an even layer of glue into the space you want to fill, spreading it around to reach all the corners. You may do more than one space at a time if they're the same color. Pour some sand onto a plate and scoop a bit of sand into your straw chakpu. Tap the straw to dribble sand onto the glued section. Let dry a minute, then tilt, blow or brush away stray grains of sand back onto its plate. Continue until your entire mandala is covered.

Tibetan Prayer Flags

Tibetan Prayer flags or *lungta*, which means "wind horse," are usually tied to the edge of a roof or strung between poles or trees. As the wind blows them, it carries the blessings and loving kindness for all beings. Over time, the sun, wind and rain will fade the flags, which like the brushing away of the sand mandalas represents the temporary nature of all things.

Prayer flags come in five colors: blue for space, white for water, red for fire, green for air, and yellow for Earth. On them are five animals: a flying horse, Garuda (a bird-like deity) eating a snake, a dragon, a tiger, and a lion. Each represents some aspect of Buddhism.

To make prayer flags, simply cut squares of fabric and decorate them with symbols and colors that are important to you. To attach them to the string for hanging, you can fold over the top of each square and staple or stitch it around the string.

Sources and Resources

Books

Tibetan Designs coloring book and *Mandala Tattoos* by Marty Noble
Ruth Heller's Designs for Coloring: The Far East
Tibet, the Secret Continent by Michel Peissel
The Dalai Lama and *Buddha* by Demi
Tibetan Tales for Little Buddhas by Naomi C. Rose

Websites

The Minnesota Institute of Art
http://www.artsmia.org/art-of-asia/buddhism/yamantaka-mandala.cfm
Shows a permanent sand mandala being built and preserved, with an explanation of its symbols.

Cornell University
www.graphics.cornell.edu/online/mandala/
3-D computer rendering of the "palace" in a sand mandala painting.

**Lama Karma Chopal creating a
sand mandala at The College of Saint Rose**

Girls Go Tech Mandala Maker
www.girlsgotech.org/mandala.asp
Design mandalas online at Girl Scout site

Mandalabre www.mandalarbre.com
Paper Mandalas www.papermandalas.com/mandalas.htm
Printable mandala coloring pages

The Tibetan & Himalayan Digital Library
www.thdl.org

Creative works and learning resources, including online Tibetan language videos

The Mystical Arts of Tibet
www.mysticalartsoftibet.org
Music, art and other Tibetan culture.

Dalai Lama's website
www.dalailama.com

Tibet Tour
www.tibet-tour.com
Interesting facts, including recipe for yak butter tea!

Ice Age Cave Paintings
Prehistoric Mammals Preserved

Cave bears, saber toothed tigers, wooly rhinos: back in the Ice Age, there was no shortage of dangerous animals for early mankind to deal with. Humans armed with stone-tipped spears roamed plains and forests hunting enormous mammals. Of course, not every prehistoric creature was a threat. Like their present-day counterparts, ancient horses, cattle, and birds lived peaceably side-by-side with mankind. Aurochs, the ancestors of today's oxen, and elks with enormous antlers covered Europe; penguins lived along the Mediterranean Sea. Judging by the mastodon bones found near ancient cooking fires, they must have once been a popular menu item all across North America.

Then, around 10,000 years ago, however, whether because of climate change or overhunting by man, Ice Age mammals began to disappear. Luckily, the people who saw them alive managed to leave us pictures of these strange and wonderful beasts -- not photographs, but beautiful and haunting cave drawings. In France, Spain and elsewhere, prehistoric artists worked deep in hidden caves, creating images which archeologists think were intended to magically ensure good hunting. The earliest known drawings, going back 30,000 years, were discovered in the Chauvet-Pont-d'Arc cave in France in 1994, but other primitive art galleries like Lascaux and Altamira have been studied for decades. Cave drawings were often stylized, with tiny heads and limbs and huge bellies, but by using line and shading to show details like hair and muscle, and overlapping figures or showing them slightly turned, the painters made their artwork lively and three-dimensional.

For materials, cave artists used minerals like iron ore, manganese, and ocher as "crayons" or ground them to a powder and mixed them with sticky animal fat to create earth-toned paints. Colors were applied with fingers, sticks, bits of fur or plants. Charcoal was used for drawing. Sometimes they carved designs right into the soft limestone with sharp flint tools. And bumps and cracks in the cave walls became part of the paintings. To see in the cave's darkness, they burned fat in shallow stone lamps; wooden scaffolds were built to reach high ceilings and walls.

Cave Wall Directions

Create a "cave wall" from a slab of Styrofoam

Materials

Large flat piece of Styrofoam, *about* 2 inches thick
Plastic knives, old spoons, etc.
Spray paint OR acrylic paint and stiff brushes

1. Carve and press the foam with the tools and your fingers until it resembles a rocky cave surface (but don't make it too uneven, or you won't have room to draw).

2. Spray-paint or use stiff brushes to fill the cracks with black or other dark shades. This creates depth.

3. Dab or spray light grey- or sand-colored paint onto the rest of the cave wall. A mixture of colors gives a realistic stone effect.

4. When the cave wall is dry, let the shape of the surface suggest a creature, as cave artists appeared to do. They used knobs and outcroppings in the rock to make the animals stand out. (See drawing directions, next page.)

5. Hang your "discovery" on a wall – or, for the adventurous, inside a dark, quiet closet – where it can be preserved for future generations to study and enjoy.

Cave Drawing Directions

You can make your own cave drawings of Ice Age bison, snow owls, and trout with vine charcoal and colored oil pastels. Scraps of chamois cloth (the kind used for cleaning cars) or suede-colored felt can be used to blend and shade. If you use a large piece of rough paper, several artists can work at once on filling the space with herds of galloping horses or hunters confronting a cave bear.

Sources and Resources

Books

Prehistoric Mammals by Alan Turner
Painters of the Caves by Patricia Lauber
Prehistoric Mammals Coloring Book by Jan Sovak

Websites

French Ministry of Culture
www.culture.gouv.fr/culture/arcnat/en/
English-language site about Lascaux and Chauvet caves

National Museum of Natural History in Washington, DC
www.mnh.si.edu/museum/VirtualTour/Tour/First/IceAge/
Ice Age mammal display

American Museum of Natural History in New York City
www.amnh.org/exhibitions/permanent/fossilhalls/curatorvideos/
Video tour with paleontologist Mike Novacek

Huichol Indian Yarn Art

Recording Nature Myths

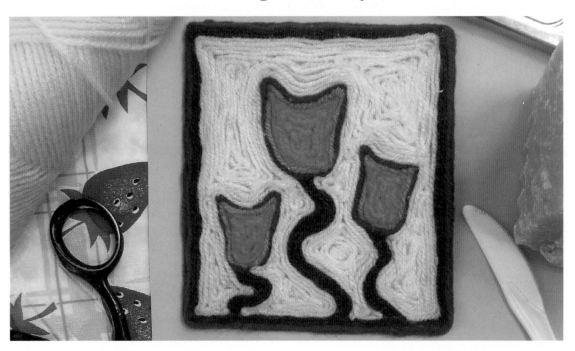

The native people of Mexico had extensive civilizations throughout the area for thousands of years. They built huge cities using their advanced knowledge of math and science, and their art reflected their intricate spiritual traditions. At the same time, some Indians lived in smaller groups with their own traditions.

The last major Indian empire in Mexico was the Aztecs. But about 20 years after Columbus sailed from Spain to America in 1492, Spanish conquistadors led by Hernan Cortes defeated the Aztecs and took over Mexico. They brought Spanish culture and religion to the native people, who absorbed the European traditions into their own way of life. One group, the Huichol (WEE-chole) were able to escape the Spanish influence until the 1700s. The Huichol live in the remote Sierra Madre Mountains, far from cities and towns. Some Huichol still live the way their ancestors did, in pre-Columbian times dating back to the ancient Olmec empire. Others have taken their traditions, including their beau-tiful crafts, to the cities, where they have become popular with the rest of Mexico.

Traditionally the Huichol believe that their ceremonies and offerings keep the world in balance. Because they had no written language or oral traditions, figures such as Father Sun, the spirit deer Kahullumari, the butterfly, and the eagle, appear in symbolic form in their visual artwork, helping to pass their stories down from generation to generation.

One type of Huichol art is yarn painting, or *nierika*. Using a mixture of tree resin and beeswax they glue yarn to boards to create pictures of religious scenes. These are left at sacred sites such as caves, temples and springs. The bright colors of their artwork almost seem to seem to vibrate because of the way they outline shapes with alternating warm (yellow, orange, red) and cool (blue, green, purple) colors.

Yarn Painting/*Nierika* Directions

Traditionally a nierika is made on a board with warmed beeswax as glue. Sometimes a mirror is made part of the design. You can get beeswax from crafts stores or from beekeepers (try your local farmers market) and follow the preparation steps below, or just use a glue stick. The techniques are basically the same.

Materials

Wooden plaque (from craft or dollar stores) OR thick, stiff cardboard cut into any shape
Pencil
Grated beeswax OR a glue stick
Reflective Mylar (the inside of a potato chip bag works well)
Yarn in several colors
Scissors
Chopstick or other object with a blunt point

1. If using beeswax, use a grater to shred the wax. Spread a thin even layer on your board and allow to soften, NOT melt, in the hot sun or *carefully* under a gooseneck lamp. Draw your design with a stick in the soft wax.

2. If using a glue stick, draw a simple design in pencil on your base (or just follow the shape of the board). Cover the drawing with a *thick* layer of glue.

3. To insert a mirror into the design, cut a circle out of the Mylar and glue it in the middle of the base.

4. Cut a piece of yarn about a foot long. Outline the base with the yarn and trim. Press the yarn into the glue with your fingers or the flat end of the chopstick. Outline the pencil design or mirror the same way.

5. Fill in the outlines with different colors of yarn, working from the outside in toward the center.

6. Use the point of the chopstick to poke the yarn into any tight corners.

7. You can turn your design into a refrigerator magnet by attaching self-sticking magnetic backing or gluing on a give-away thin bendable magnet, cut to size.

Eye of God/*Ojo de Dios/Sikuli*

The Eye of God is the most well-known Huichol craft. In Spanish it is called Ojo de Dios and in the Huichol language Sikuli, which means "the power to see and understand things unknown." Every child gets one at birth to ensure a long and healthy life. As soon as a child is born, the father weaves a central eye on two long sticks. Then every year an eye is added to one of the ends until the child is five. The resulting design symbolizes the four elements of earth, air, fire and water. The Huichol keep their personal Sikuli throughout their lives and use them in healing rituals, First Fruits and Thanksgiving ceremonies. Today the craft is also a Mexican tradition, hung over children's beds as a good luck charm while they sleep.

Materials

Sticks or dowels, 4-6 inches for short ends, 12 inch for long ends
Yarn in different colors
White glue and toothpick to apply
Beads, bells, feathers, and other decorations

1. Cut a length of yarn to use for the first color 2 or 3 feet long.

2. Cross 2 or more sticks and tie them together with yarn.

3. Begin winding the yarn around the sticks: starting at the top, pull the yarn gently over the next stick and bring it around under that stick. Continue until every stick has one turn of yarn.

4. Go around again, being careful to lay the yarn next to previous layer. Keep going until you have an area of color as big as desired.

5. Start the next color: Clip the remaining yarn to 2 or 3 inches and hold it in place. Cut a new length of yarn in the next color and start wrapping at the same place you left off. Before going on the next color, tie the ends of the first and second colors together and clip as short as possible.

6. When finished, tie off the end and clip. If desired, wrap the stick in yarn. To keep the yarn from slipping off the stick, put a little glue on the stick with the toothpick and hold in place until set, about 30 seconds.

7. Add decorations and a cord to hang the craft to the ends if desired.

8. To make a craft with multiple "eyes," make the first eye with long sticks. Add small eyes to the end of each stick, using small sticks as cross bars.

Sources and Resources

Books

The Journey of Tunuri and the Blue Deer by James Endredy (picture book with yarn painting illustrations)

The Tree That Rains: The Flood Myth Of The Huichol Indians by Emery and Durga Bernhard (picture book)

The Eagle and the Rainbow: Timeless Tales from Mexico by Antoio Hernandez Madrigal

Art of the Huichol Indians by Lowell John Bean (art catalogue for adults with many photos)

Websites

The Bead Museum of Glendale, Arizona
www.beadmuseumaz.org/Huichol
Lesson plans for the Huichol Web of Life Creation and Prayer Exhibition

Artist Jay Mohler
http://ojos-de-dios.com
Directions for making your own 8-sided version

Xavier Quijas Yxayotl
www.yxayotl.com
Music and flutes by a Huichol artist

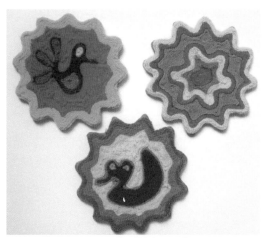

Yarn paintings from Mexico

General World Crafts
Sources and Resources

Books

Art from Many Hands: Multicultural Art Projects by Jo Miles Schuman

Websites

Hands on Crafts for Kids
www.craftsforkids.com
A public television program with hundreds of crafts instructions on its website, featuring themes like habitats of the world, world history and US customs and symbols.

Incredible Art Department
www.princetonol.com/groups/iad
Teachers' lesson plans, with photos and directions, tying in art with all kinds of subjects.

Dick Blick
http://www.dickblick.com/info/productinfo/
An art supplies catalog website with a section of tips for using materials, and lesson plans for multicultural crafts.

Exploratorium
http://www.exploratorium.edu/explore/handson.html
Cool, easy science projects to build.

About the Author

Photo: John Ceceri, Jr.

Kathy Ceceri is the creator of the "Hands-On Learning" column for *Home Education Magazine* and a crafts designer and writer for newspapers and magazines including *FamilyFun*, *Sesame Street Parents*, *Child* and *The* (Albany, NY) *Times Union*. She also teaches learning crafts for enrichment programs at schools and libraries and for homeschool groups. Kathy received her Bachelor's in English Literature from McGill University in Montreal and studied art at Parsons School of Design and School of Visual Arts in New York. She lives with her husband in Schuylerville, New York, where they homeschool their two sons. Kathy is currently working on a guide to emergency and short-term homeschooling.

Kathy enjoys speaking about homeschooling and presenting learning crafts programs to children and adults. Visit her website **www.craftsforlearning.com** or contact her at kathy@craftsforlearning.com.

Printed in Germany
by Amazon Distribution
GmbH, Leipzig